D

Katharina Bosse

NEW BURLESQUE

Essay by Cécile Camart

d·a·p

DISTRIBUTED ART PUBLISHERS, INC.
NEW YORK

Babette la Fave

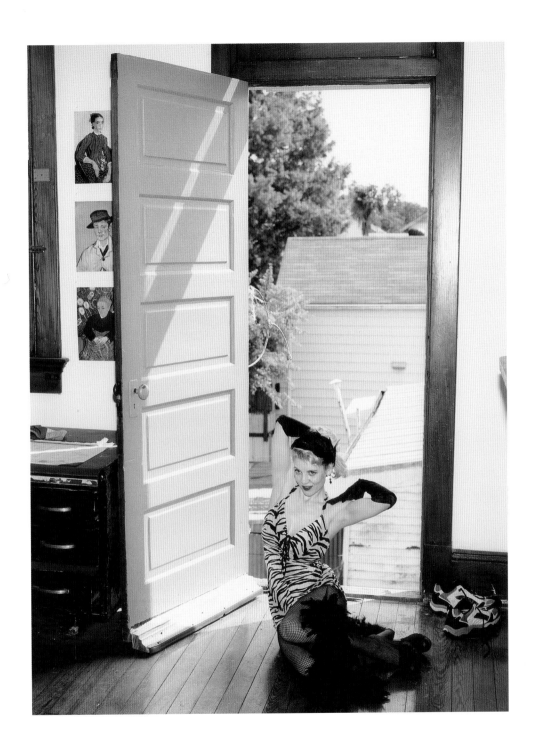

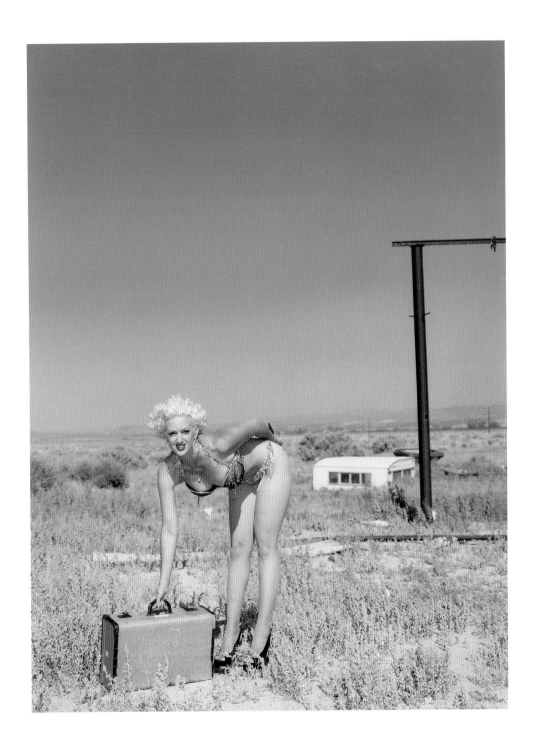

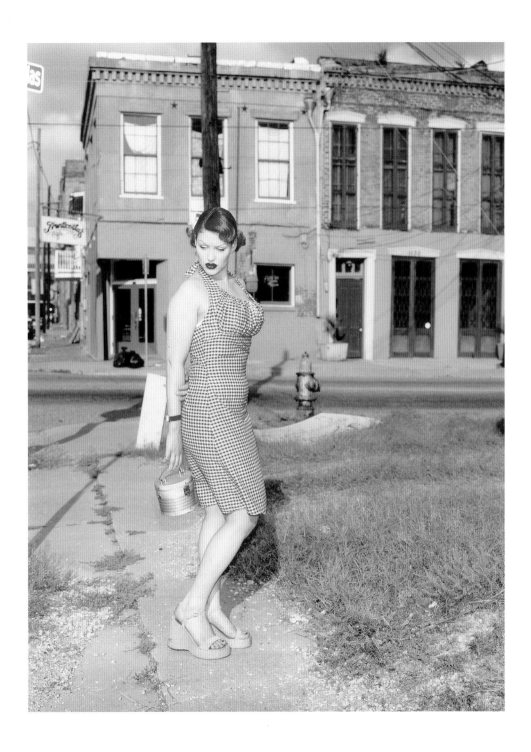

Ruby Darling

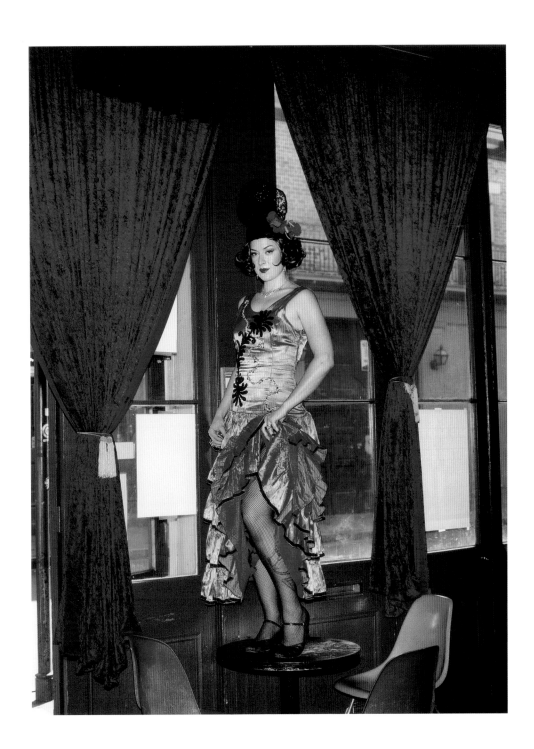

Dirty Martini

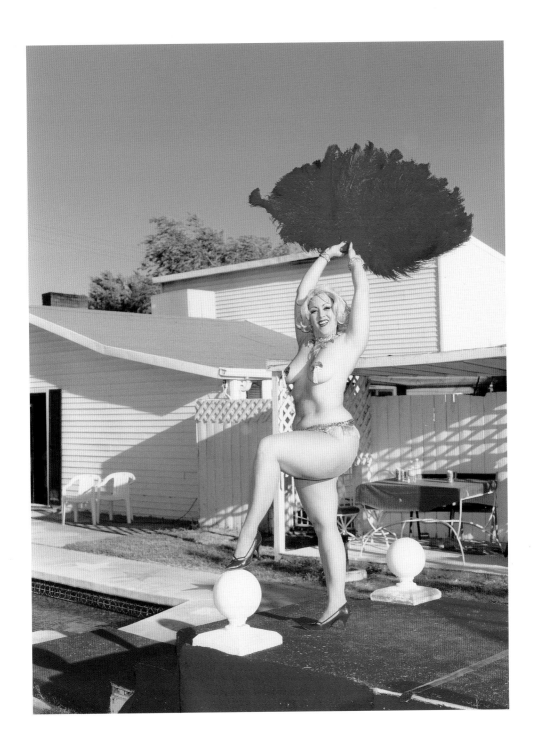

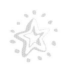

D'Milo

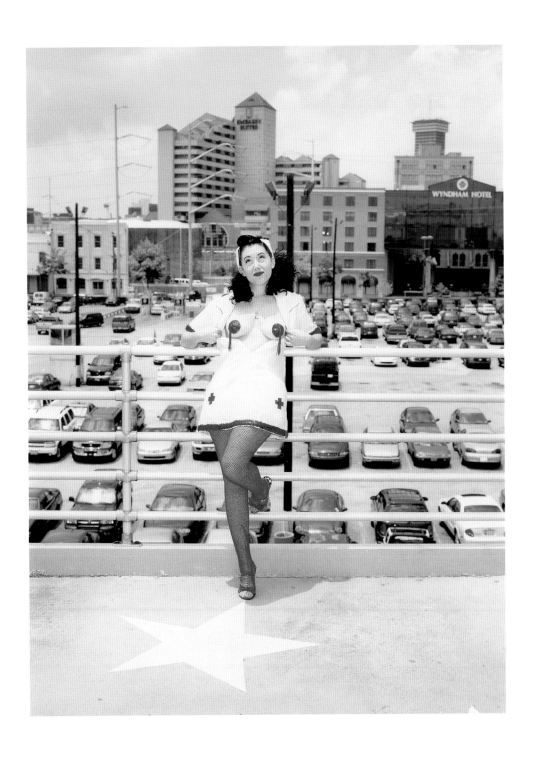

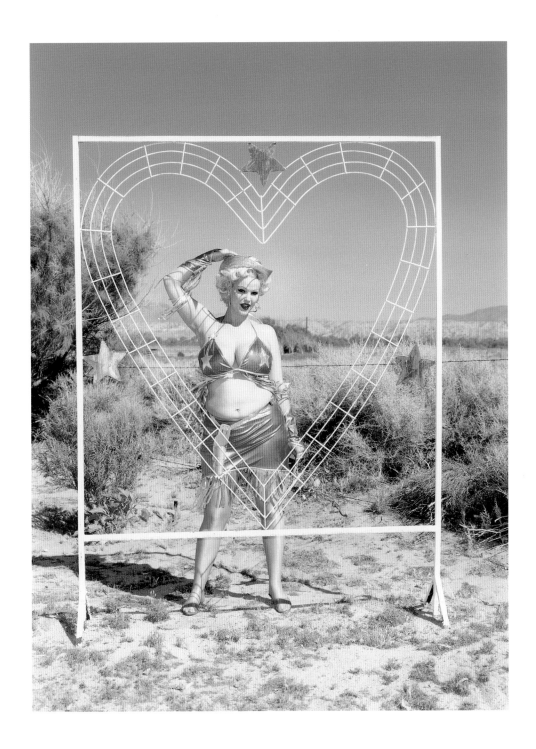

Dormouse (Gael)

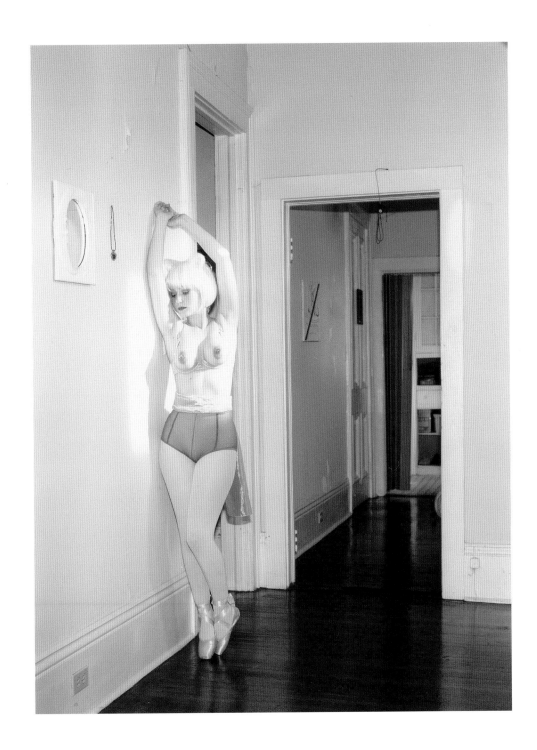

Starlet O'Hara

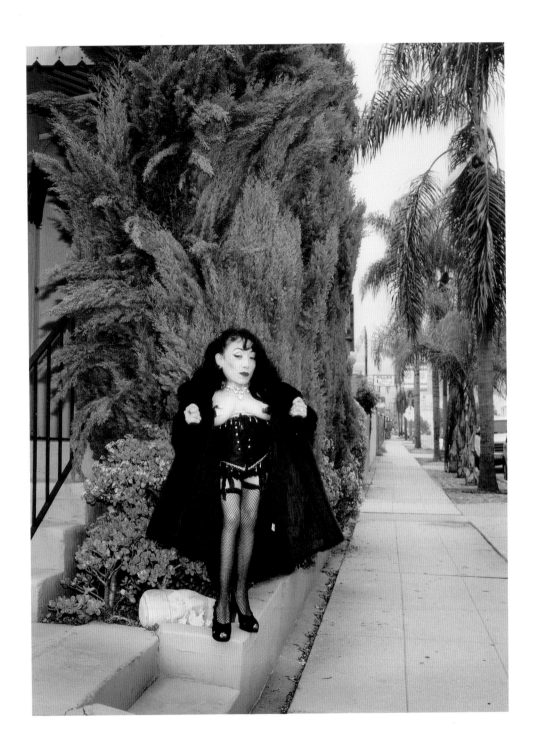

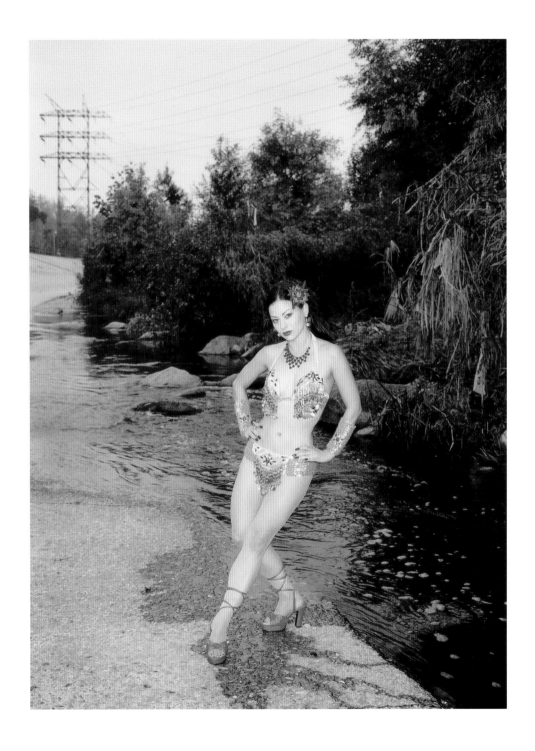

Ursulina

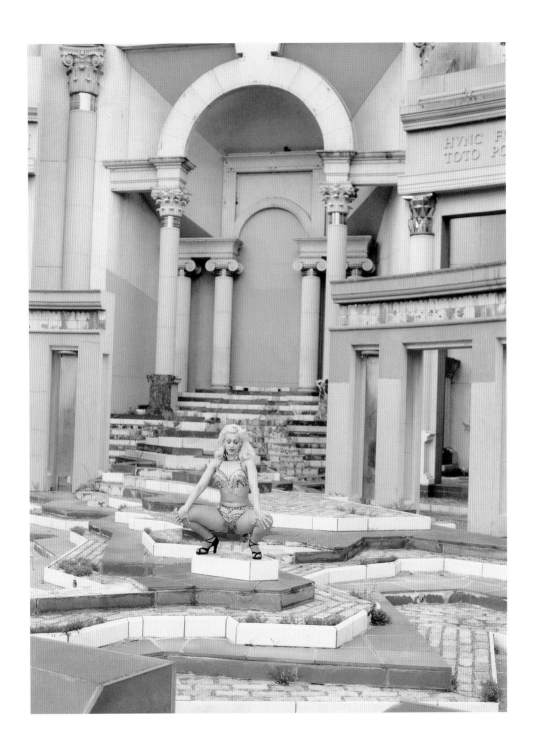

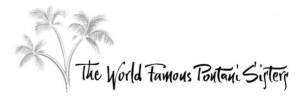

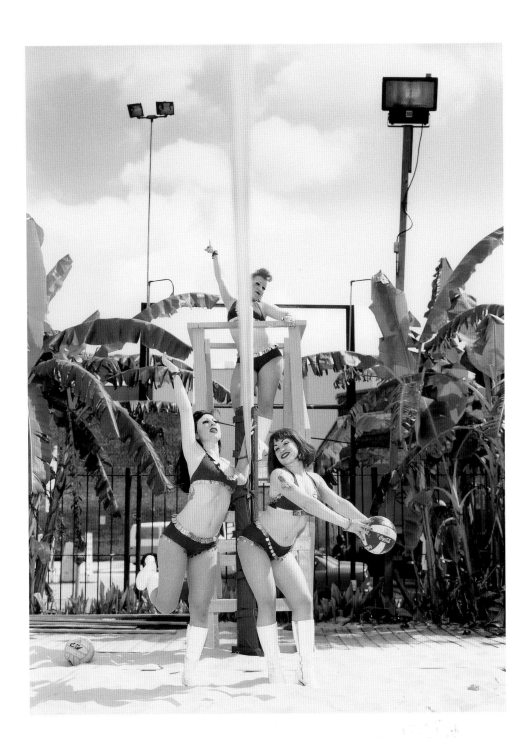

The Blaze

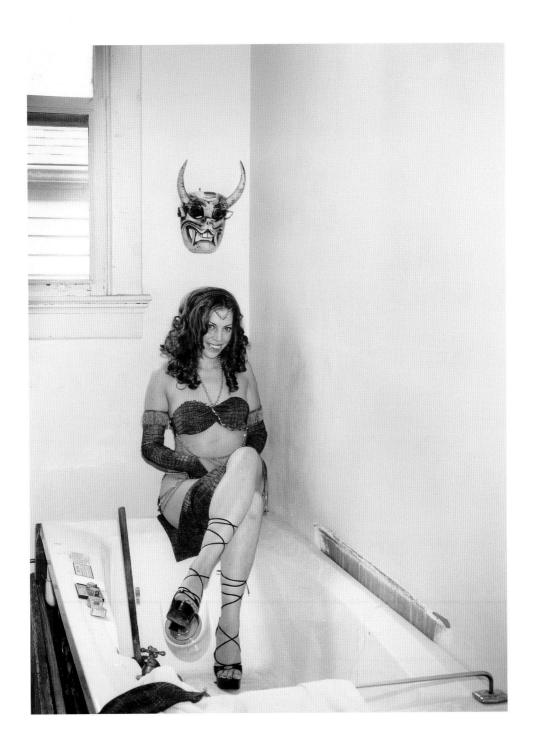

Hangman Lola

Stella Starr

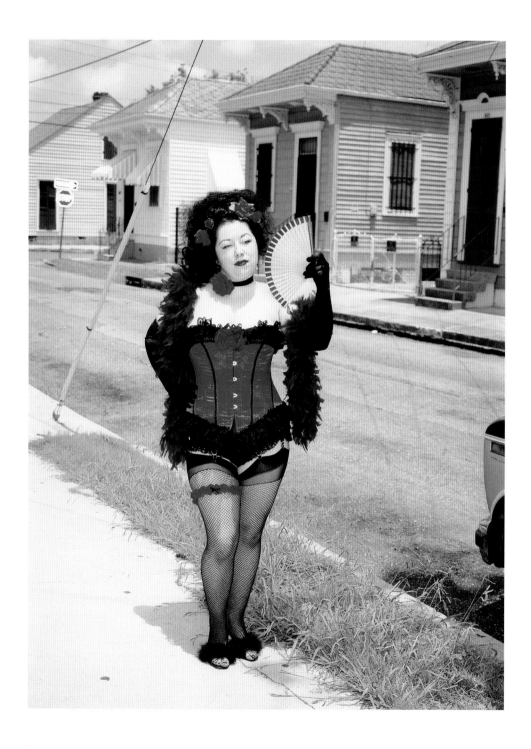

Candy Whiplash

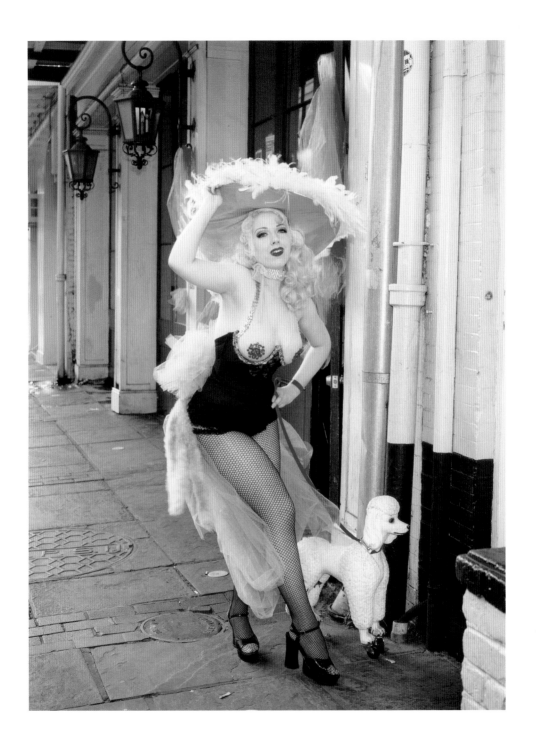

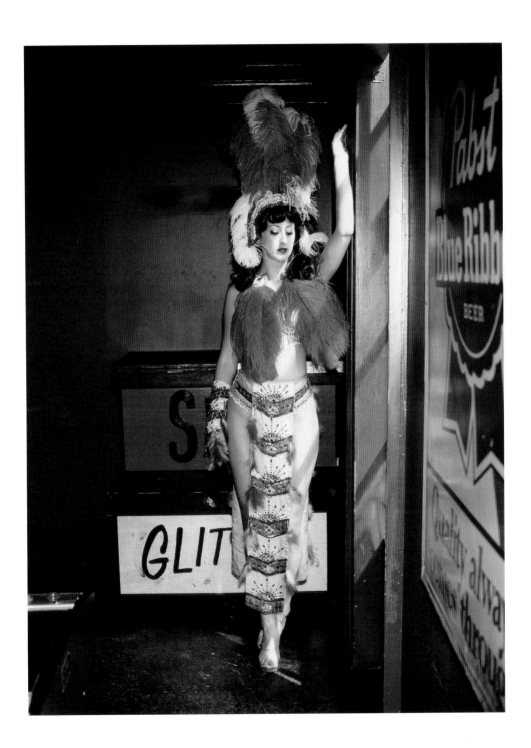

Minnie Maracas

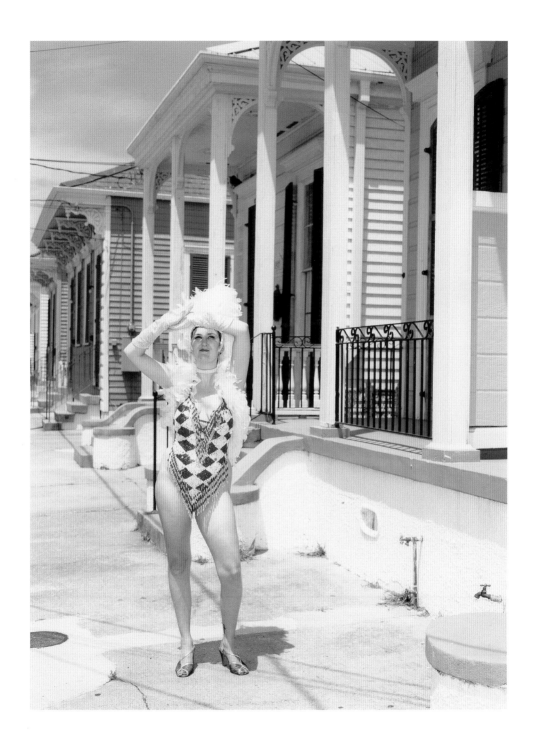

Carina and Katla

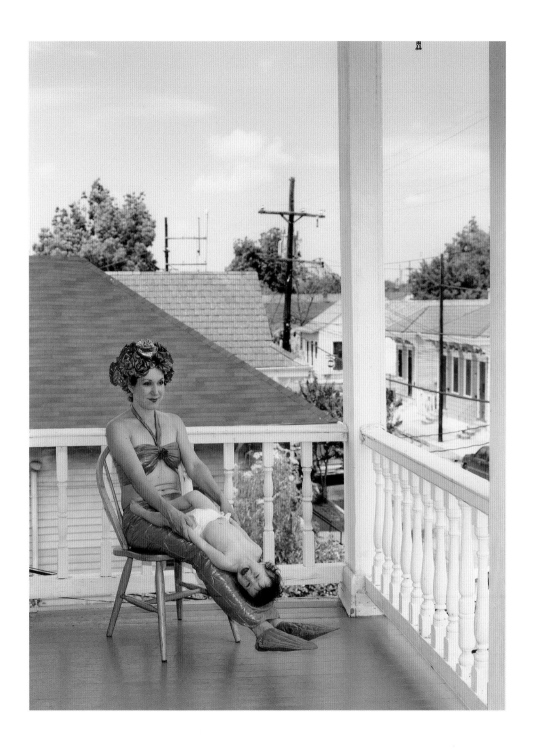

Pebbles

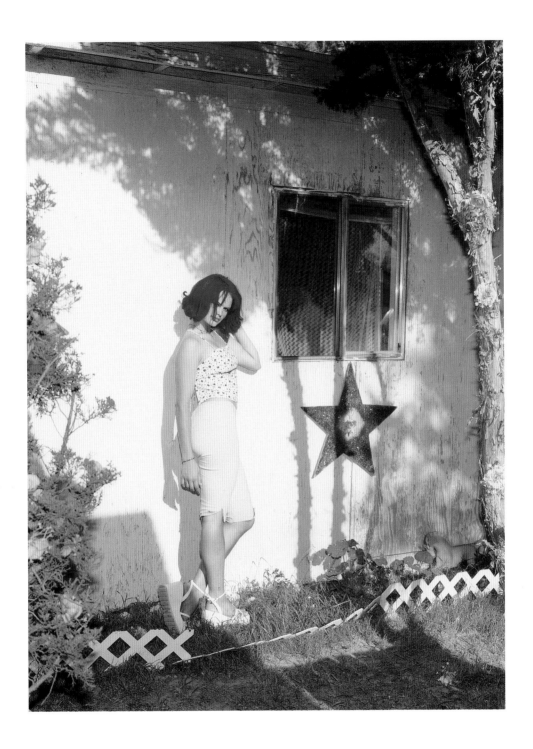

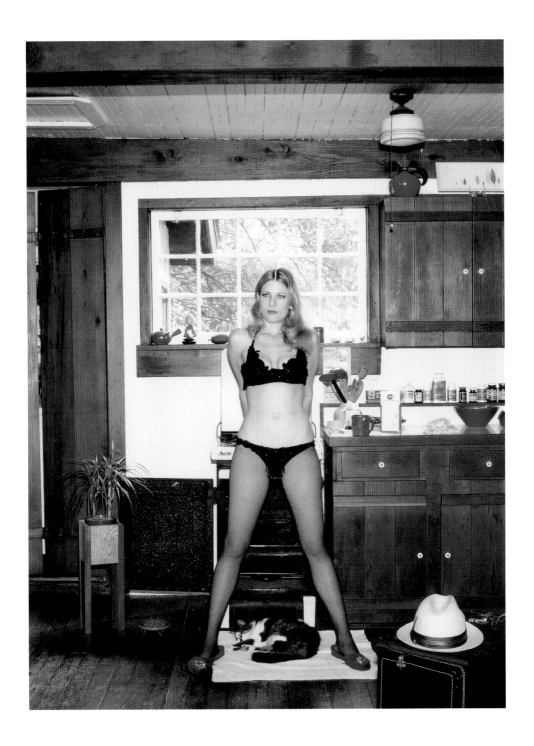

The Thrill Seeker

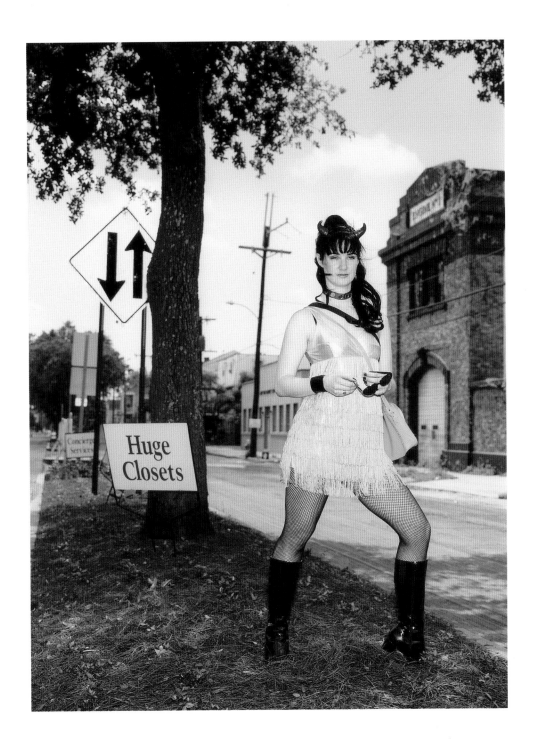

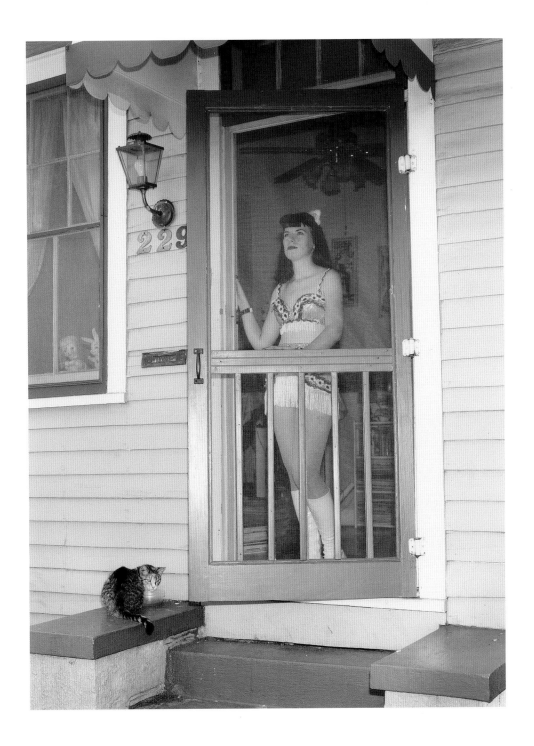

Lorelei Lane

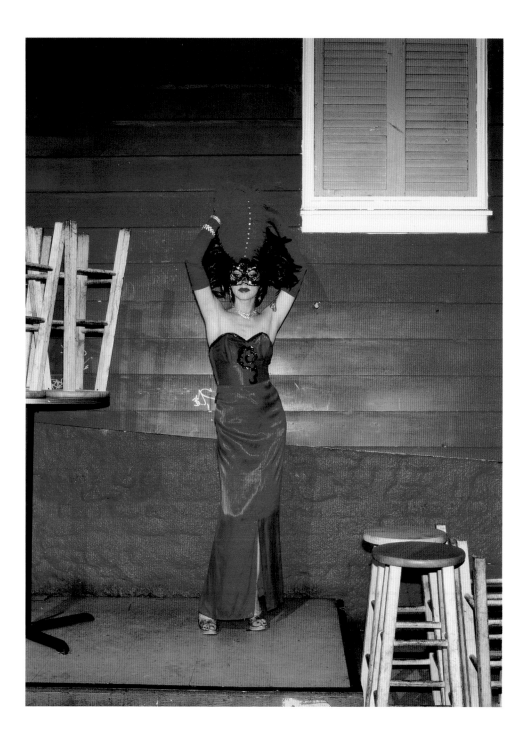

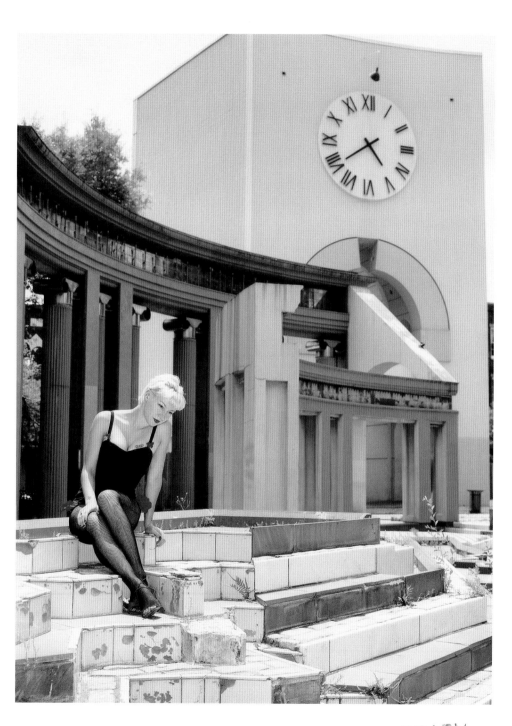

THE HENLEY COLLEGE LIBRARY

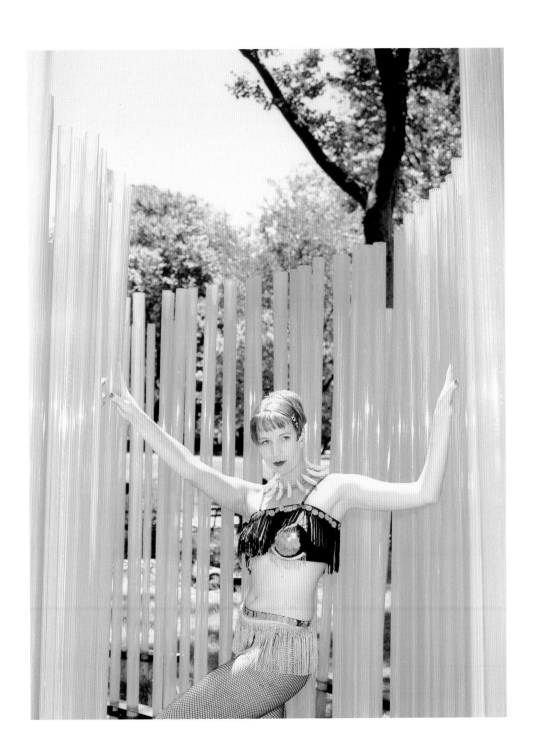

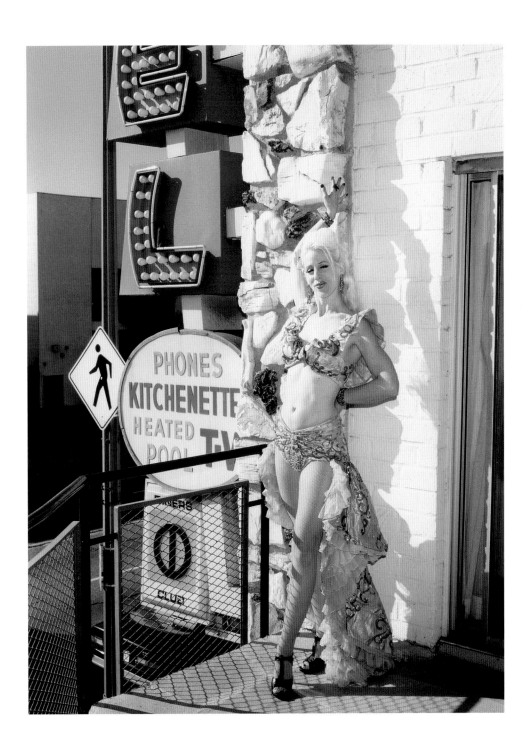

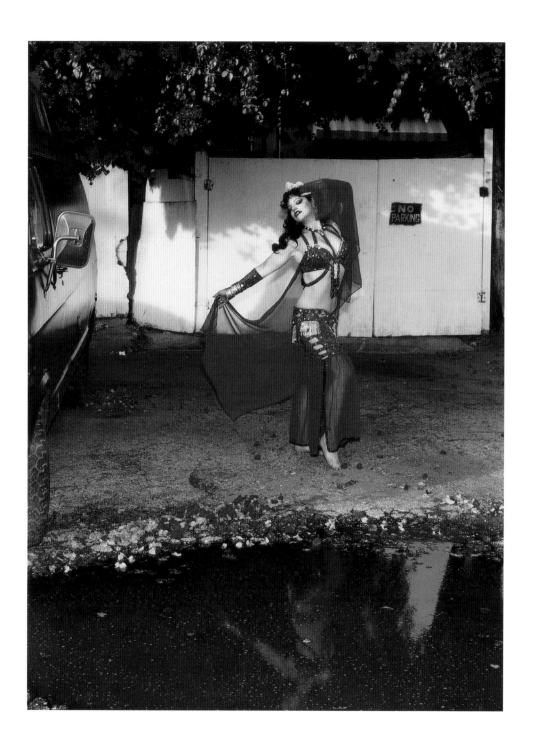

Queen of Hearts (Gael)

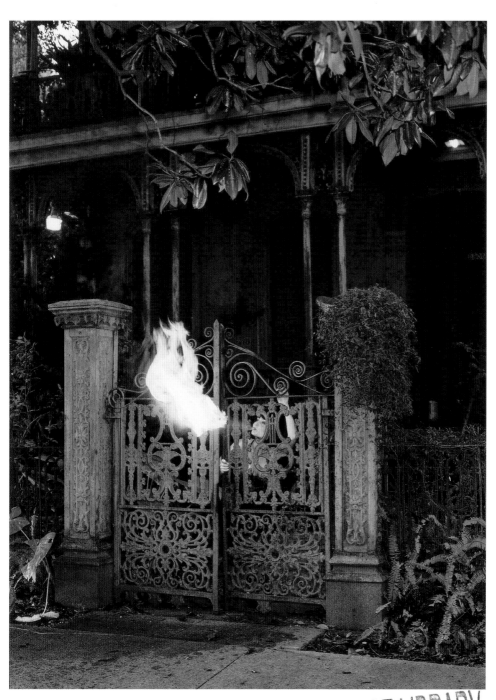

THE HENLEY COLLEGE LIBRARY

Julie Atlas Muz

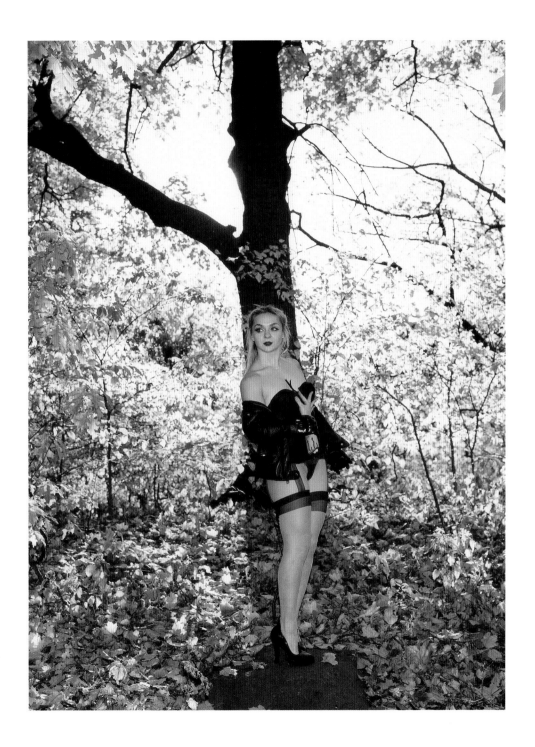

Zoe Bonini

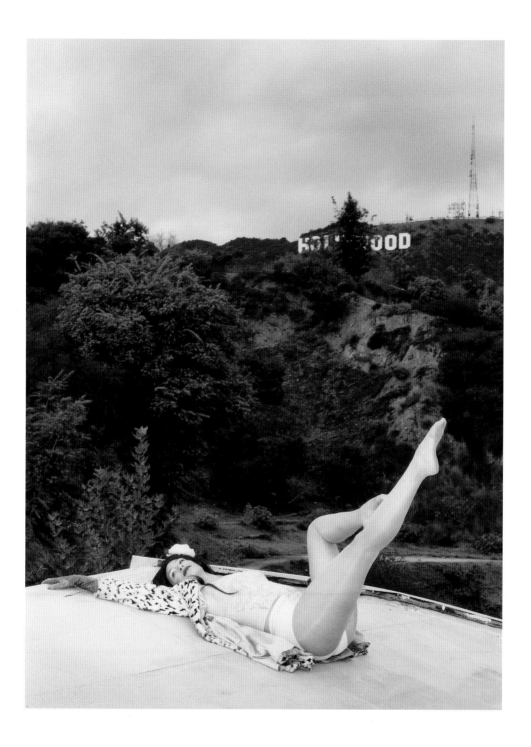

Kitten On The Keys

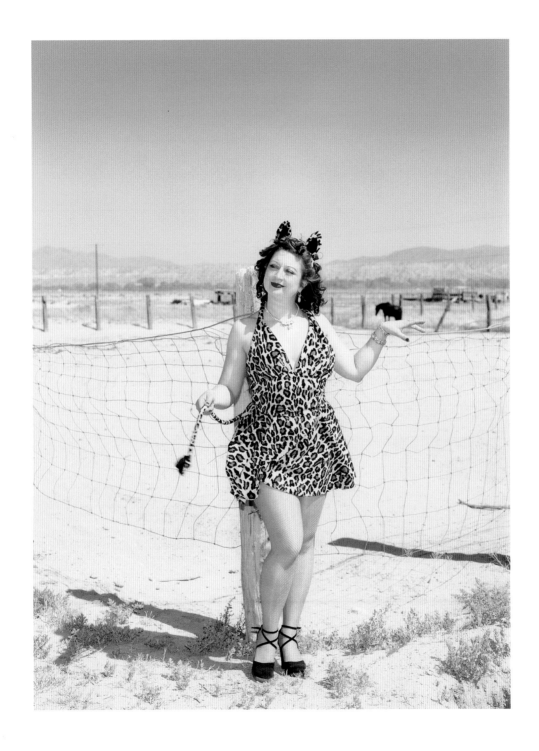

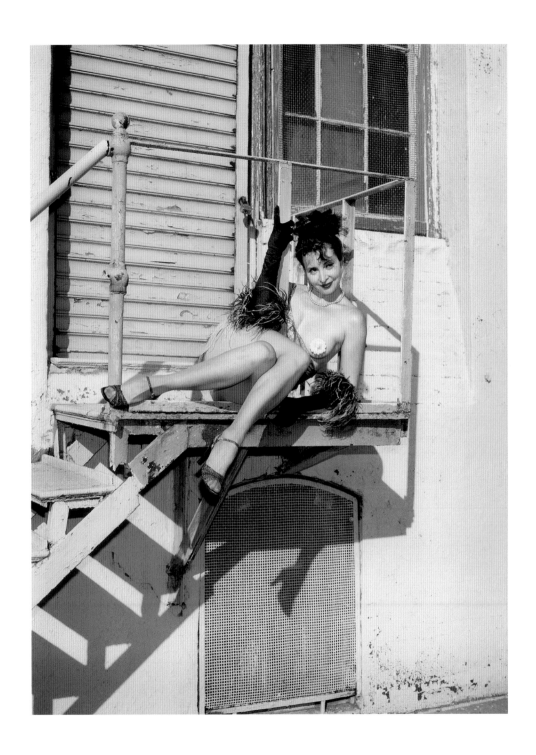

Dagger Lee

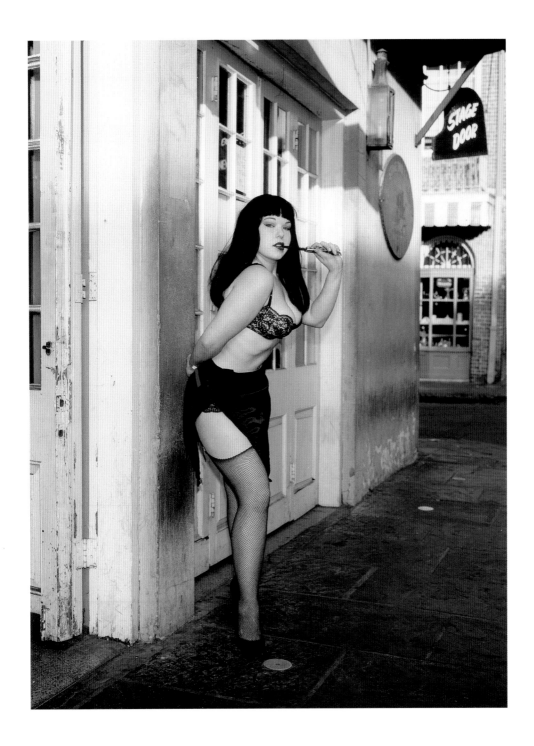

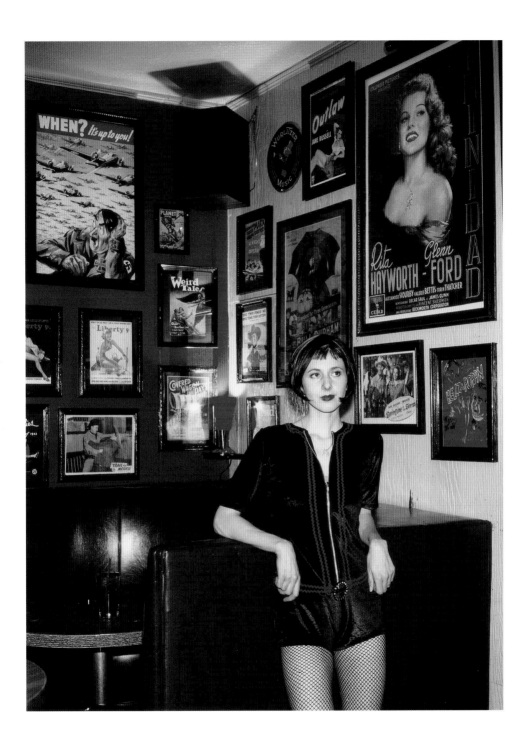

Violetta Valentine

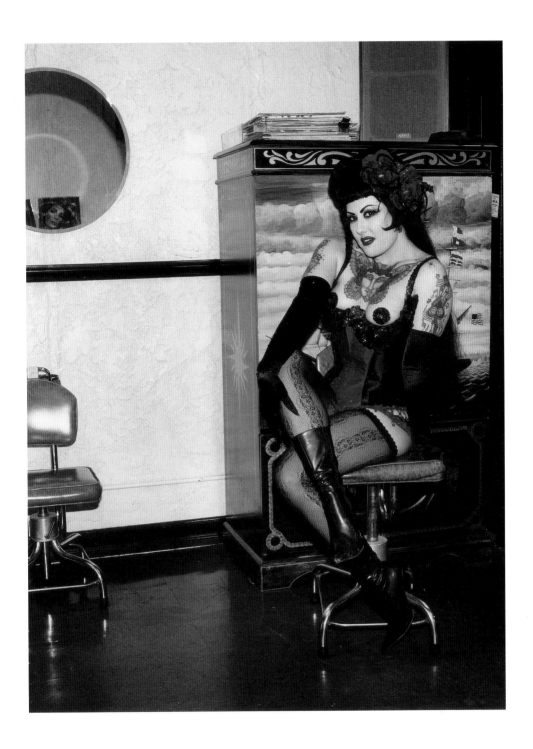

Miss Dynatease

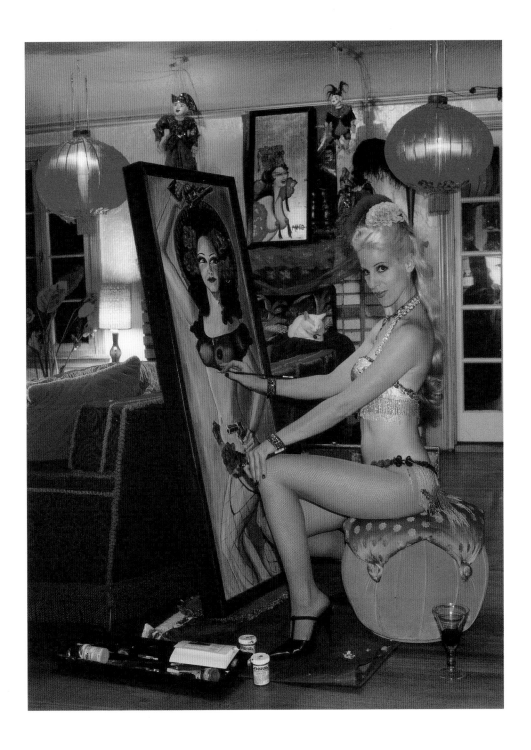

New Burlesque or The Veil of Pretence

*"The photo-portrait is merely a closed force field. Four types of imagination intersect,
confront each other and are deformed. Before the lens, I am simultaneously:
he who I think I am, he who I want people to think I am, he who the photographer
thinks I am and he who the photographer uses to exhibit his art."*
Roland Barthes

The specificity of the burlesque world, as it is revisited by contemporary American performers and explored by Katharina Bosse, is by nature a paradox: one of rerouting and defocusing, sometimes to infinity. The key to this long series of photographs may lie here, reached via a preliminary etymological exploration of the notion of "burlesque."

While Katharina Bosse's undertaking has its origins in a long journey across America between 2001 and 2002 to meet each woman, the nature of her photographic "intervention" cannot be reduced to a strictly documentary or sociological dimension. Her portraits of burlesque dancers, as we will see, reveal a form of sublimated desire underlying this systematic – and ironic – attitude of opposition to established norms, in order to better introduce the disturbing specificity of the photographed subject. New Burlesque thus functions as a system of subverting modernist codes. Katharina Bosse fully indexes this *inversion* process: her photographs invite us to penetrate into the heart of a space that she interposes between reality and re-presentation, between the presence of the incarnated subject and the projection of fantasies.

Before it was a show business genre, burlesque – followed by the recent appearance of New Burlesque – was first an attitude. This burlesque activism takes on the forms of a desired, constructed and accepted rerouting of – or reaction against – socially predetermined conventions and imageries, and finally a de-framing that nonetheless takes place in the context of a *mise en scène* and a questioning of the representation of oneself.

Polysemy and Polyvalence of Burlesque

From the Italian "burla" (farce, joke), the term first consecrates, in the strict sense, a literary genre designating a reaction in the 16th and 17th centuries against the preciousness of poetic language, which aims to deride the heroic situations of epic fiction. More generally, the burlesque can also be the parodical style practiced since Antiquity and Petrarch's *Satyricon*. We must now explore the commonly established links with the semantic field of

outrage, exaggeration, pastiche – or even caricature, as well as that of extravagance, comedy, buffoonery and grotesque. These highlight the main directions in which the complex forms of New Burlesque have developed today.

In American English, in the middle of the 19th century, the word took on a very specific meaning: "burlesque" came to mean any sort of variety show, characterized by a wide range of light comedy or dance and often including striptease.[1] The meaning thus gradually changed, introducing an element of female sexuality as an integral part of burlesque theatrical performances to the point of overriding the first meaning, or even reducing burlesque to striptease alone. A brief survey of the short history of burlesque in the United States allows us to identify more easily the different forms of reaction that New Burlesque incarnates today.

Englishwoman Lydia Thompson and her troupe of "British Blondes" introduce burlesque to New York in 1868 and soon won the favor of the press and public who stormed the Broadway theater. From 1893, the belly dancer Little Egypt, star of the Chicago World Fair, added an Oriental dimension to burlesque. The golden age of burlesque occurred between the 1900s and the 1930s. American theaters of this period presented the great stars of burlesque, such as Lilly St. Cyr, Rose la Rose and Gypsy Rose Lee, which the major contemporary figures of New Burlesque still refer to explicitly today. The Great Depression temporarily put an end to this splendor, with ultimate censorship practiced in 1937 by the mayor of New York, F.H. La Guardia, who ordered the closure of the theaters concerned. Between the 1930s and the 1950s, burlesque progressively became the most popular form of American theater. It was a cheap form of entertainment characterized by stars in the most extravagant costumes, cheerful choreography influenced by Broadway revues and unstoppable humor. From the 1950s onwards, the costumes became flashier, with an increasing nudity factor.

Faced with the widespread and trivialized commercialization of striptease that started developing in the 1960s and 70s, a certain number of dancers and troupes have organized a revival of the golden age of burlesque. New Burlesque is multi-disciplinary. Striptease is *one* of the show practices, along with group or solo dances, comedy and circus acts, parodies, vaudeville, songs, choirs and live music. The range of the burlesque "renaissance" is vast, from "historical" versions, similar to the original shows, to updated versions that sometimes include the punk esthetic of the 1980s. American affection for this important part of their cultural history also has institutional manifestations. Somewhere between Los Angeles and Las Vegas, dancer Dixie Evans – the famous "Marilyn Monroe of Burlesque" in the

[1] "*U.S.: a variety show, often including strip tease…*", in : Oxford Modern English Dictionary, 2d edition; "*A variety show characterized by broad ribald comedy, dancing and strip tease*", in: The American Heritage Dictionary of the English Language, 4th edition.

1950s – runs a museum devoted to burlesque. Each year the Exotic World Burlesque Museum organizes a competition which also attracts dancers from New Burlesque. Here, Katharina Bosse photographed certain major figures of the new generation for her series, including *Kitten De Ville, Dirty Martini, The World Famous *BOB**, and *Kitten on the Keys*.

There are noteworthy regional occurrences and particularities from New York to Seattle, via New Orleans, Memphis, Denver, Portland, Atlanta, Vancouver, Los Angeles and San Francisco. The close relationship between burlesque shows and the New York artistic and performance scene is of some significance, highlighting a probable conscious or unconscious acculturation of feminist art movements. Conversely, the sumptuousness of decors and grandiloquence of the shows performed in theaters on the West Coast no doubt refers to the popular imagery of Hollywood movies.

A Post-Modern Attitude

Each burlesque performer meticulously constructs a character and a strong identity through the choice of a stage name – an *avatar* – a carefully composed costume with emblematic accessories, as well as through perfectly mastered acting and choreography. A certain form of irony and probable inspiration from conventional "pin-up" poses are the common denominator. At this stage, the re-appropriation of an identity and a specificity that distinguishes her from the accepted image of the commercial stripteaser can be established.

In her photographic series, Katharina Bosse immediately brings up the question of women's image from the angle of the inversion of the process of *re-presentation*. She deliberately chooses to extract each of the burlesque performers from her spectacular context, favoring instead diurnal photographs in the everyday environment. Putting forward a stage character acting out a posture behind which is a double identity suddenly blurs the line between public sphere and private sphere.

Images by Katharina Bosse in which we encounter some of the criteria set out by Abigail Solomon-Godeau in the 1980s – serial approach, appropriation, simulation or pastiche[2] – can be qualified as post-modern in that the social and sexual positioning of the "seeing subject" is key. "While it is admitted that post-modernist practice favors the referent over the autonomy of the esthetic signifier, we must add that the referent is considered as problem and not as data,"[3] suggests Abigail Solomon-Godeau. In the act itself, New Burlesque constitutes a pastiche or "remake" of forms of modernism. The photographic reconstitution of scenes in broad daylight infinitely multiplies this distancing, superimposing another screen on the reading of the image. Douglas Crimp's reflection on the subject of post-modern photography takes on its full meaning here: "*The desire for representation only exists if it is*

[2] Abigail Solomon-Godeau, *Art after Modernism: Rethinking Representation*, New York, The New Museum of Contemporary Art, Brian Wallis ed., 1984, pp. 75-85.

[3] *ibidem*.

never satisfied, as long as the original is always deferred. It is only in the absence of the original that representation can occur."[4]

This feature of New Burlesque could be seen as replaying the history of male perspective in light of gender studies. There is no dominant male structure behind these shows, and the full social and economic autonomy of these women is completely unlike the commercial striptease that exists in other spheres today. Moral and physical integrity is preserved. Burlesque striptease does not attain total nudity. The pleasure and energy of "playing" a character and taking on a different identity are predominant. Katharina Bosse surely feels fascination for this pride in being oneself, much like Nan Goldin, who affirmed (for different reasons and with respect to her photographs from the 1970s and 80s): *"whether you're a transvestite or a body-builder, it's all about having the guts to transform your own image."*

In Katharina Bosse's photographs, we find the same effacing of the artist behind the identity and presence of the subject as in Cindy Sherman's – despite the fact that the latter takes a central position in her photographs. The series *New Burlesque* reflects a number of clichés from collective memory fed by the history of the music hall as well as advertising images and cinematographic codes. However, the distancing proposed is not one of social criticism. Katharina Bosse does not seek to dismantle female stereotypes, but rather shows us *how* women have appropriated these codes, in taking full responsibility for the reception of their image as well as the fantasies linked to the public representation of their "acted" bodies. It is through an extreme theatricalization of the *mise en scène* that the photographer attains her goal.

Scenography of Portraiture

Beyond the cultural context she confronts, Katharina Bosse's images participate in the tradition of photographic portraiture and post-modern practice, as indicated above. Although she was trained in Germany, Katharina Bosse did not follow the path laid out by the Düsseldorf school. Her practice of portraiture is completely opposed to that of Thomas Ruff, who declared, on the subject of his famous series of portraits from the 1980s: *"I wanted to do portraits in the same neutral, bare manner as my Interiors. I started with the principle that photography can reveal nothing about personality, that photography only reproduces the surface of things. (…) In truth, I only really caught the appearance of things."*[5] Between 1997 and 1999, Katharina Bosse's various portrait series, shown in the exhibitions "Signe" and "Realms of Signs, Realms of Senses,"[6] suggested a very different intention. The work of the photographer with her "models" was already about making images of the body within a chosen and constructed space.

[4] Douglas Crimp, "L'activité photographique du post-modernisme", in: (cat.) *L'époque, la morale, la mode, la passion*, Paris, Centre Georges Pompidou – Musée National d'Art Moderne, 1987, p. 604.
[5] Interview with Thomas Ruff, in: *Contacts – Thomas Ruff*, film, 13 mins, directed by Jean-Pierre Krief, La Sept-Arte, Centre National de la Photographie.
[6] Exhibitions *Signe*, Lukas & Hoffman Galerie, Cologne, 1997 and *Realms of Signs, Realms of Senses*, Heidi Reckerman Photographie Galerie, Cologne, 1999.

In the series *New Burlesque*, the place where each photograph is taken suggests a setting spangled with subtle clues, which may be there by chance or merely a product of our fantasies. Networks of signs are constructed inside each image, much like the physical traces of an imminent intimacy, this time thrown into the light of day – a new projector.

The places occupied are often half-closed, half-open spaces. Among the poses realized completely outdoors, we identify different types of "sets": vast landscapes (*Kitten de Ville*), deserted streets (*Kitty Crimson*), a parking lot seen from above (*D'Milo*), a red podium (*Dirty Martini*), to the "Piazza d'Italia," which places *Ursulina* and *Trixie Tanqueray* in Roman decor. Some of the photographs were taken in the burlesque dancers' private interiors. There is a recurring presence of the "frame": the framing of a window or door, sometimes in a row – as in the photograph of *Dormouse*, in a standing pose, leaning against a white wall where the sun's rays project a rectangle. The milky, soft atmosphere that results is relayed by the classical ballet shoes she wears: while the interior is sober, each detail is striking. *Babette LaFave*, for example, poses sitting under the light in front of the frame of a door that opens out onto nothingness. Inside we see fragments of her daily life, such as a pair of sport socks and reproductions of paintings pinned to the wall. When we observe the portrait of *Mimi Kersting*, we cannot help thinking of one of the artist's earlier series, "From inside/from outside" (1995). The woman stands behind the half-open glass front door of her house, which forms a screen placing the model both inside and outside. The relation to desire becomes problematic. The open and closed construction of the space again places the subject in a frame, in the heart of our field of vision.

"Signs" punctuate the whole series. Behind *Bebe Bijoux*, an incomplete slogan on a trunk, "GLIT," suggests the word "glitter" and is echoed by the advertising or urban graphics that frame the poses of *Ming Dynatease* and *The Thrill Seeker*. The motif of the "star" appears several times: on the front of Pebbles' house, on the glamorous costume of *The World Famous *BOB**, and at the feet of *D'Milo*. The costumes and postures are always sumptuous and seem to bounce off each other, from the orientalism of *Farhana*, a contemporary "Salome" with whirling veils, to the style of *Vivienne Va-Voom*, much like Josephine Baker, or the bouncy choreography of the *World Famous Pontani Sisters*.

Cinematography is also explored. *Lovella La-La-Lamay* springs out of a black car, like a character from David Lynch's *Mulholland Drive* (although it was made earlier). The famous HOLLYWOOD sign on the hill can be made out behind *Zoe Bonini*. And finally, the very natural *Honey Touche* is presented in a bar covered in movie posters where we can clearly make out a portrait of Rita Hayworth in "Affair in Trinidad," a late remake of the famous "Gilda." Should we understand a barely disguised irony here?

Within her series, Katharina Bosse constructs a network of spaces that function between the effect of contrast (*Honey Corday* in her traditional kitchen with a cat between her feet) and the illusion of the appropriateness of the environment. The major role played by color allows the subject to forge links with her surroundings: her series "Printing Colors" (1997) already placed this question at the heart of the artist's photographic practice.

It is clear that the *mise en scène* is omnipresent, insistent and also enigmatic. It interposes another veil – of pretence? – where one's own fantasies can be freely projected. This was true of the impressive earlier series of American interiors, taken of rooms rented out for the day to allow the enactment of an erotic fantasy to fit the different sets on offer.[7] With Katharina Bosse, the construction of space becomes theatricalization and extravagant scenography. The set appears either minimal or intimate; magnified, cinematographic or monumental.

In her lounge room decorated with Chinese lanterns and hanging marionettes, *Ming Dynatease* chose a seated pose, like a painter in front of her canvas, holding a paintbrush. It is tempting to see a *mise en abîme* of portraiture and the model's pose (the canvas represents a burlesque dancer). It is as if this photograph crystallizes the issues of the entire series.

How can we still practice portraiture today? Katharina Bosse answers this question by composing photographic images in which the postures are exaggerated and extravagant; where the poses are hypertrophied and the gestures frozen. Through this perilous exercise, her "models" attempt to condense the very essence of the characters they incarnate. They allow a presence to emerge in the "image," which suddenly takes on all its strength. Their hidden, intimate side escapes from this artificial stillness. This *un-public* femininity, which only reveals itself in the context of a relationship with another person, suggests the progressive appearance of an extreme fragility, like a *latent* image – if only we allow ourselves to be spellbound by their gaze.

[7] *Realms of Signs, Realms of Senses* (1998-1999), in: (cat.) *Surface Tension*, Hamburg, Kruse Verlag, 2000.

Katharina Bosse
NEW BURLESQUE

Katharina Bosse would like to thank:
All the wonderful burlesque performers I have met.
Thank you for being such an inspiration. You have made my dreams of sexy,
self-assured and fun women come true. A big round of applause to you and to
everyone who has put their time and effort into presenting burlesque,
especially the gals from Burlesque Festival Teaseorama and Dixie Evans,
director of the Burlesque Museum Exotic World. Thank you to D.A.P. for
making this book come alive in the U.S., home of New Burlesque.
Across the Atlantic, cheers to Paris: Galerie Anne Barrault
and Patrick Le Bescont from Filigranes, thank you
for your support. Devoting myself to this project would have
been hard without the on-going support from Heidi Reckermann
Photographie in Cologne and Alan Koppel Gallery in Chicago.
Cecile's text is a joy. Sebastian: thank you for your beautiful drawings and
your faith in this project. A big kiss to Hendrick, whose love, enthusiasm
and graphic skills have been with me always. Let's shake it.

www.newburlesque.com

Design, Hendrick Bosse-Lange
Illustration, Sebastian Keneas
Calligraphy, Thomas Hoyer
Production, Patrick Le Bescont, *Filigranes Éditions*
Scanning, *Anthéa*, Trégueux
Translation, Heidi Wood

Managing Editor, Lori Waxman, *D.A.P.*
Additional Design, Steven Mosier
Printing, *Oceanic Graphic*, China

ISBN : 1-891024-99X

Photographs © Katharina Bosse
Essay © Cécile Camart
© Filigranes Éditions 2003

D.A.P. / Distributed Art Publishers
155 Sixth Avenue, 2nd Floor
New York, NY 10013
www.artbook.com

Library of Congress Cataloging-in-Publication Data

Bosse, Katharina, 1968-
New burlesque / Katharina Bosse ; essay by Cécile Camart.
p. cm.
ISBN 1-891024-99-X
1. Portrait photography--United States.
2. Photography of women--United States.
3. Stripteasers--United States--Portraits.
4. Burlesque (Theater)--United States--Pictorial works.
I. Camart, Cécile. II. Title.

TR681.W6B655 2004
779'.24'092--dc222004011878